DRAW 50 | Buildings and Other Structures

THE STEP-BY-STEP WAY TO DRAW
Castles and Cathedrals, Skyscrapers and Bridges, and So Much More . . .

BOOKS IN THIS SERIES

- *Draw 50 Airplanes, Aircraft, and Spacecraft*
- *Draw 50 Aliens*
- *Draw 50 Animal 'Toons*
- *Draw 50 Animals*
- *Draw 50 Athletes*
- *Draw 50 Baby Animals*
- *Draw 50 Beasties*
- *Draw 50 Birds*
- *Draw 50 Boats, Ships, Trucks, and Trains*
- *Draw 50 Buildings and Other Structures*
- *Draw 50 Cars, Trucks, and Motorcycles*
- *Draw 50 Cats*
- *Draw 50 Creepy Crawlies*
- *Draw 50 Dinosaurs and Other Prehistoric Animals*
- *Draw 50 Dogs*
- *Draw 50 Endangered Animals*
- *Draw 50 Famous Cartoons*
- *Draw 50 Flowers, Trees, and Other Plants*
- *Draw 50 Horses*
- *Draw 50 Magical Creatures*
- *Draw 50 Monsters*
- *Draw 50 People*
- *Draw 50 Princesses*
- *Draw 50 Sharks, Whales, and Other Sea Creatures*
- *Draw 50 Vehicles*
- *Draw the Draw 50 Way*

DRAW 50

Buildings and Other Structures

THE STEP-BY-STEP WAY TO DRAW
Castles and Cathedrals, Skyscrapers and Bridges, and So Much More . . .

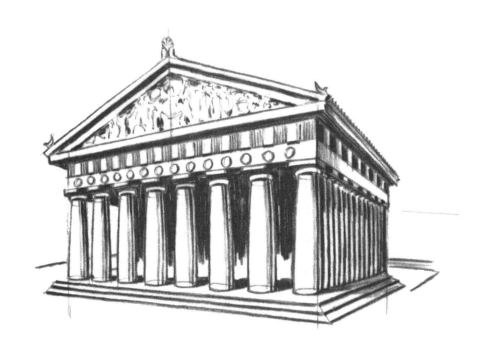

LEE J. AMES

WATSON-GUPTILL PUBLICATIONS
Berkeley

All rights reserved.
Published in the United States by Watson-Guptill Publications, an imprint
of the Crown Publishing Group, a division of Random House LLC,
a Penguin Random House Company, New York.
www.crownpublishing.com
www.watsonguptill.com

WATSON-GUPTILL and the WG and Horse designs are registered
trademarks of Random House LLC.

Originally published in hardcover in the United States by
Doubleday, a division of Random House LLC, New York, in 1980.

Library of Congress Cataloging-in-Publication Data

Ames, Lee J.
 Draw 50 buildings and other structures.

 1. Buildings in art. 2. Drawing—Technique.
 I. Title.
 NC825.B8A44 743'.84
Library of Congress Catalog Card Number 79-7483

ISBN 978-0-8230-8604-7
eISBN 978-0-8230-8605-4

Printed in the United States of America

12

2014 Watson-Guptill Edition

To Alfie

Many thanks to Holly Moylan for all her help.

To the Reader

This book will show you a way to draw buildings, bridges and other structures. You need not start with the first illustration. Choose whichever you wish. When you have decided, follow the step-by-step method shown. *Very lightly* and *carefully* sketch out the step number one. However, this step, which seems the easiest, should be done *most carefully.* Step number two is added right to step number one, also lightly and also very carefully. Step number three is sketched right on top of numbers one and two. Continue this way to the last step.

It may seem strange to ask you to be extra careful when you are drawing what seem to be the easiest first steps, but this is most important, for a careless mistake at the beginning may spoil the whole picture at the end. As you sketch out each step, watch the spaces between the lines, as well as the lines, and see that they are the same. After each step, you may want to lighten your work by pressing it with a kneaded eraser (available at art supply stores).

When you have finished, you may want to reinforce the final step in India ink with a fine brush or pen. When the ink is dry, use the kneaded eraser to clean off the pencil lines. The eraser will not affect the India ink.

Here are some suggestions: In the first few steps, even when all seems quite correct, you might do well to hold your work up to a mirror. Sometimes the mirror shows that you've twisted the drawing off to

one side without being aware of it. At first you may find it difficult to draw the egg shapes, or ball shapes, or sausage shapes, or just to make the pencil go where you wish. Don't be discouraged. The more you practice, the more you will develop control.

In drawing these buildings I used much reference material to insure reasonable accuracy. I've also tried, in some of the drawings, to convey a *sense* of perspective, rather than full constructions with vanishing points and projections. These can come later.

The only equipment you'll need will be a medium or soft pencil, paper, the kneaded eraser and, if you wish, a ruler, a pen or brush and India ink—or a felt-tipped pen—for the final step. The first steps in this book are shown darker than necessary so that they can be clearly seen. (Keep your work very light.)

Remember there are many other ways and methods to make drawings. This book shows just one method. Why don't you seek out other ways from teachers, from libraries and, most important...from inside yourself?

LEE J. AMES

To the Parent or Teacher

"David can draw a building better than anybody else!" Such peer acclaim and encouragement generate incentive. Contemporary methods of art instruction (freedom of expression, experimentation, self-evaluation of competence and growth) provide a vigorous, fresh-air approach for which we must all be grateful.

New ideas need not, however, totally exclude the old. One such is the "follow me, step-by-step" approach. In my young learning days this method was so common, and frequently so exclusive, that the student became nothing more than a pantographic extension of the teacher. In those days it was excessively overworked.

This does not mean, however, that the young hand is never to be guided. Rather, specific guiding is fundamental. Step-by-step guiding that produces satisfactory results is valuable even when the means of accomplishment are not fully understood by the student.

The novice with a musical instrument is frequently taught to play simple melodies as quickly as possible, well before he learns the most elemental scratchings at the surface of music theory. The resultant self-satisfaction, pride in accomplishment, can be a significant means of providing motivation. And all from mimicking an instructor's "Do as I do."

Mimicry is prerequisite for developing creativity. We learn the use of our tools by mimicry. Then we can use those tools for creativity. To this end I would offer the budding artist the opportunity to memorize or mimic (rote-like, if you wish) the making of "pictures." "Pictures" he has been anxious to be able to draw.

The use of this book should be available to anyone who *wants* to try another way of flapping his wings. Perhaps he will then get off the ground when his friend says, "David can draw a building better than anybody else!"

LEE J. AMES

Draw 50

BUILDINGS AND OTHER STRUCTURES

Empire State Building (New York, U.S.A.)

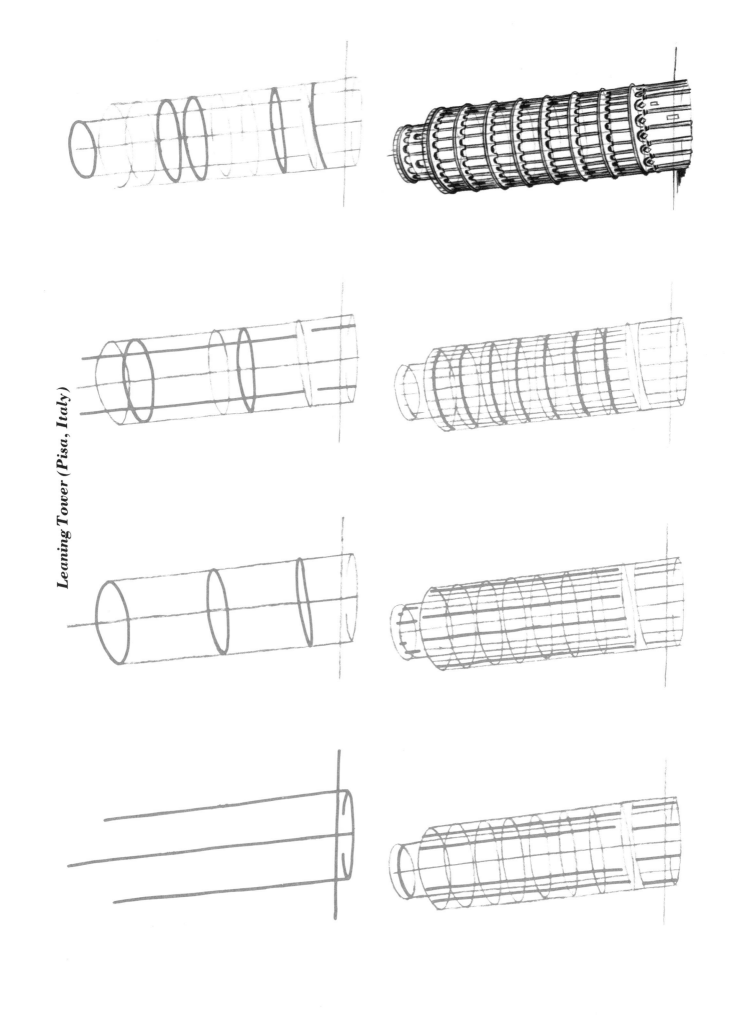

Big Ben (London, England)

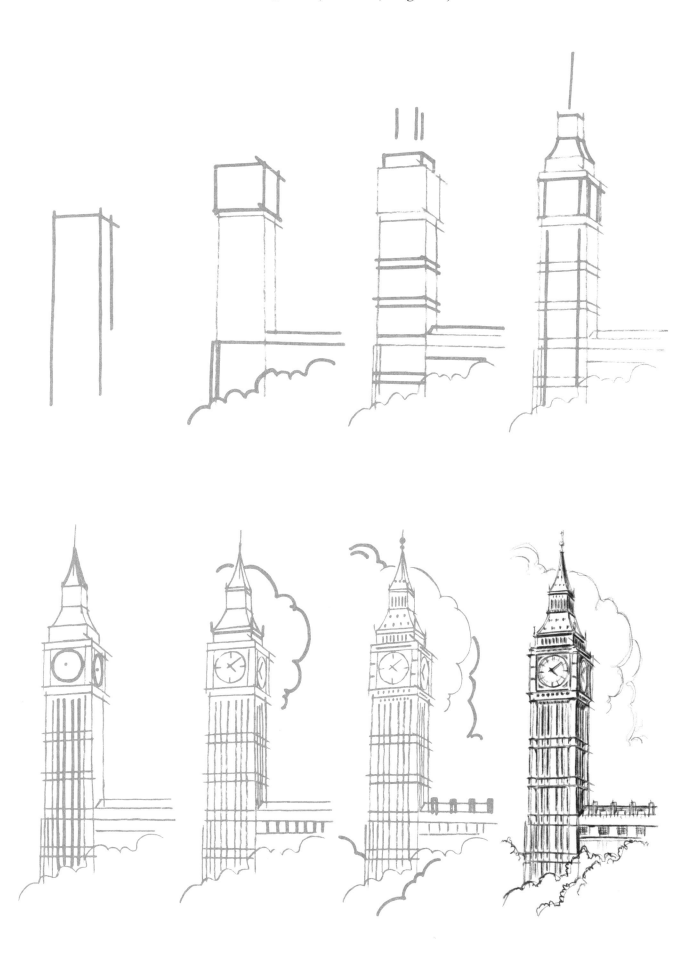

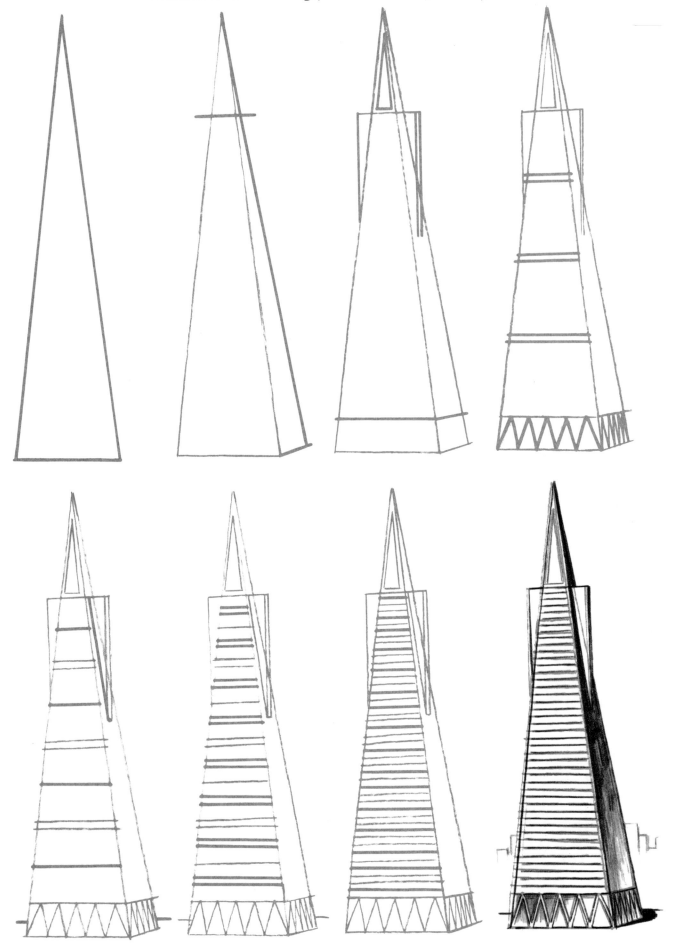

Taj Mahal (Agra, India)

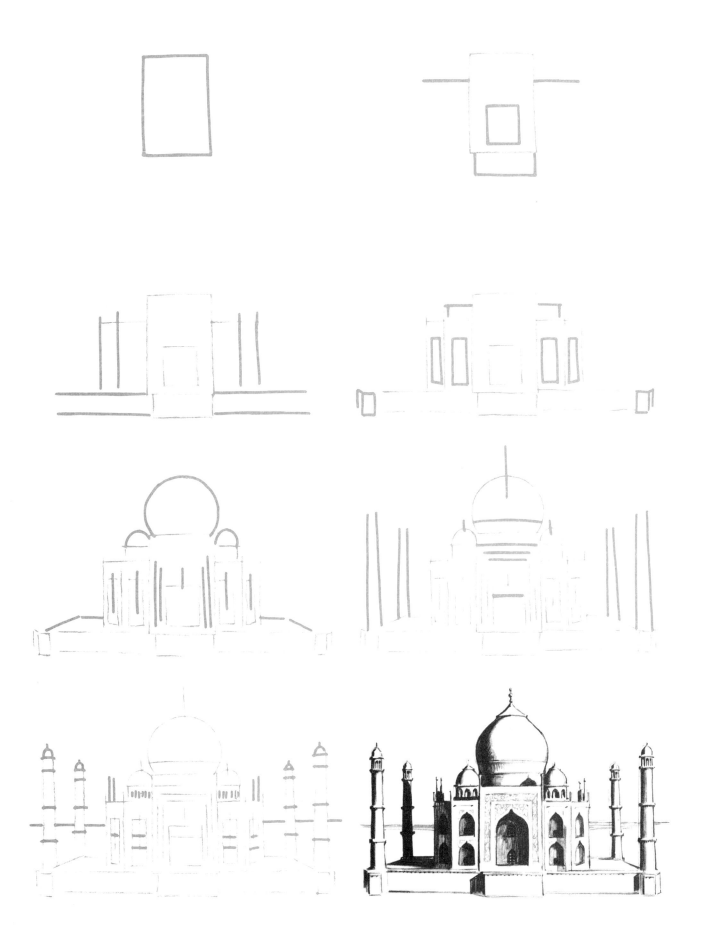

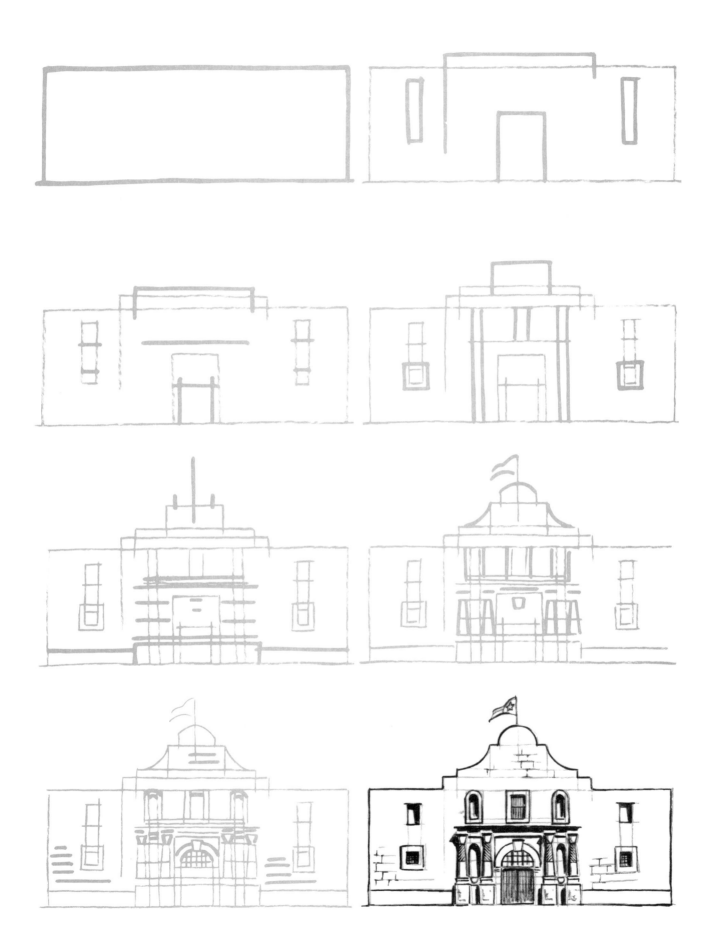

Alcazar (Segovia, Spain)

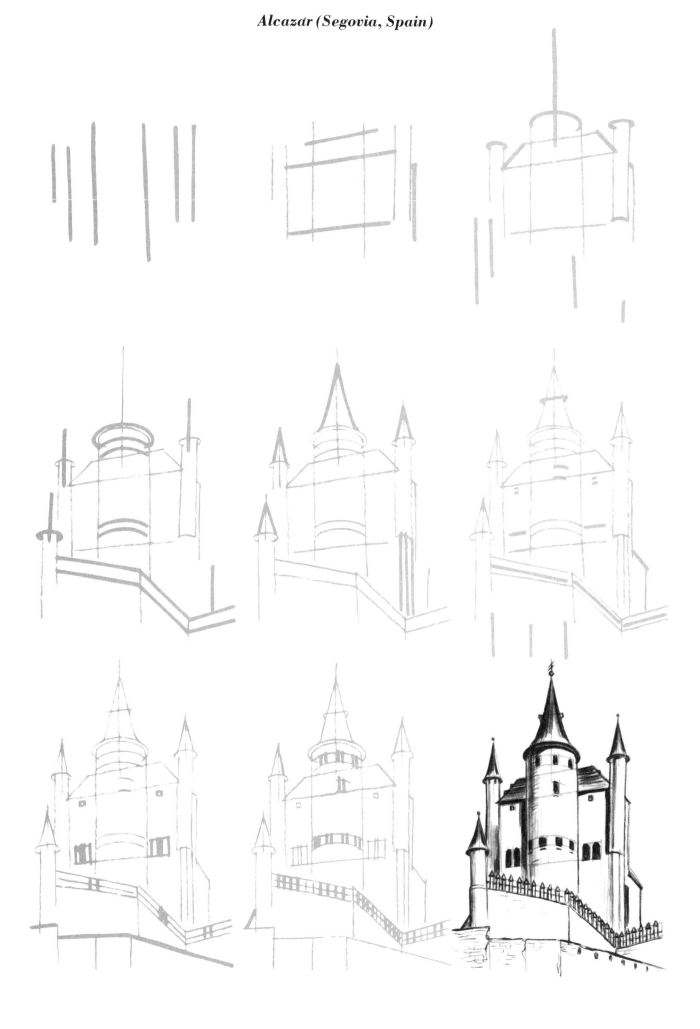

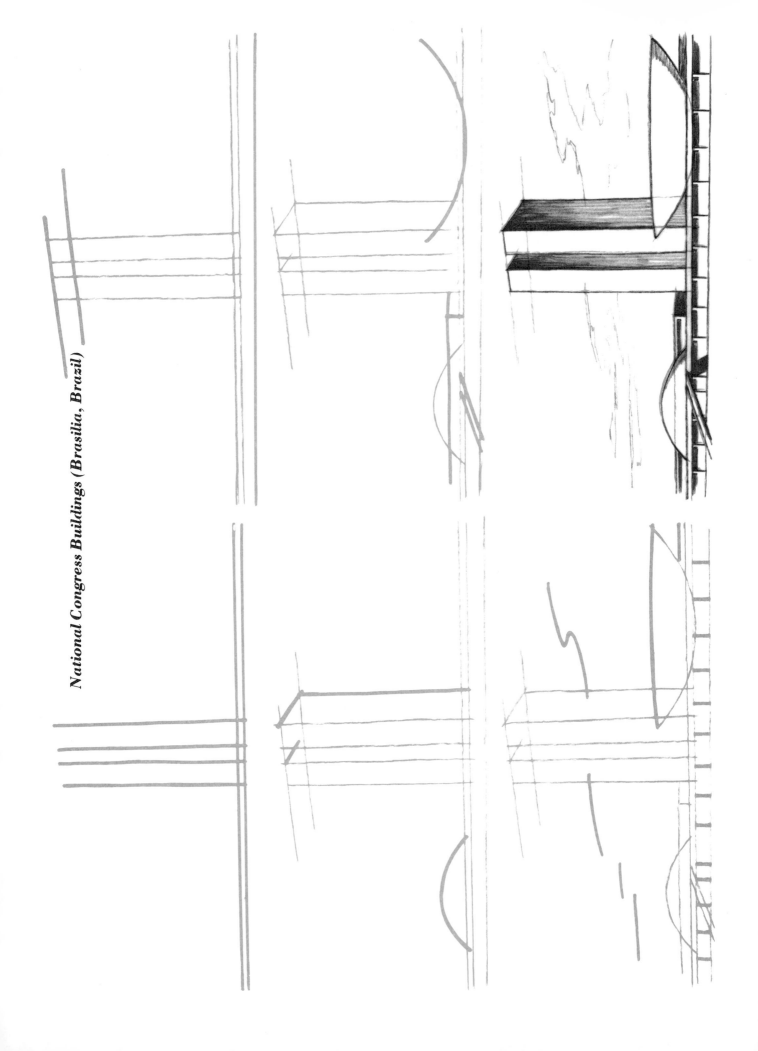

National Congress Buildings (Brasilia, Brazil)

The Parthenon (Greece)

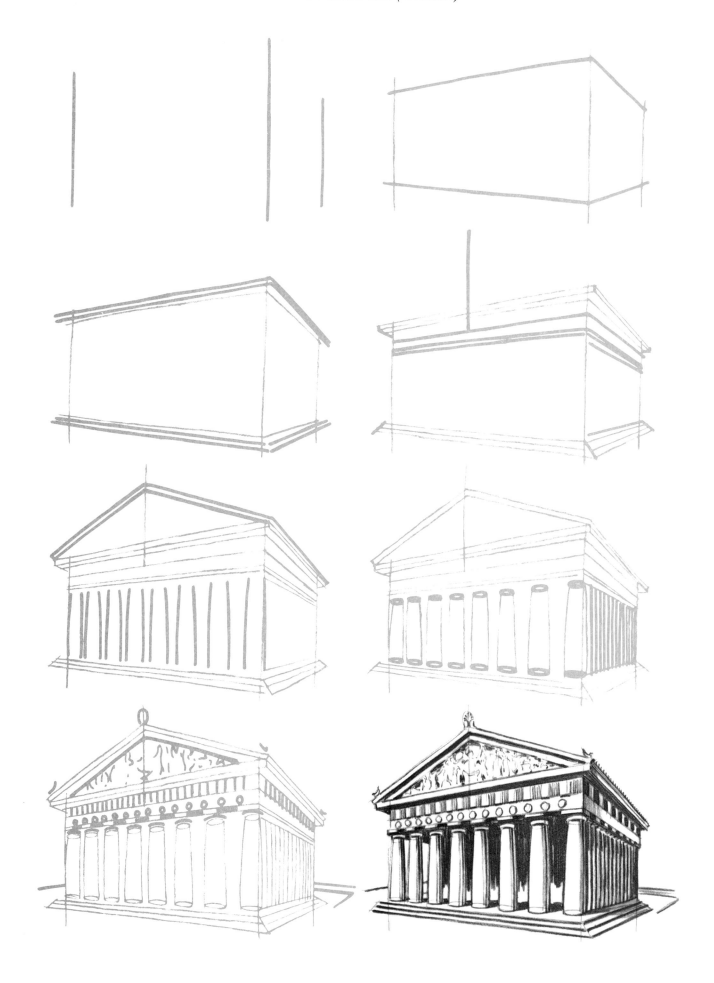

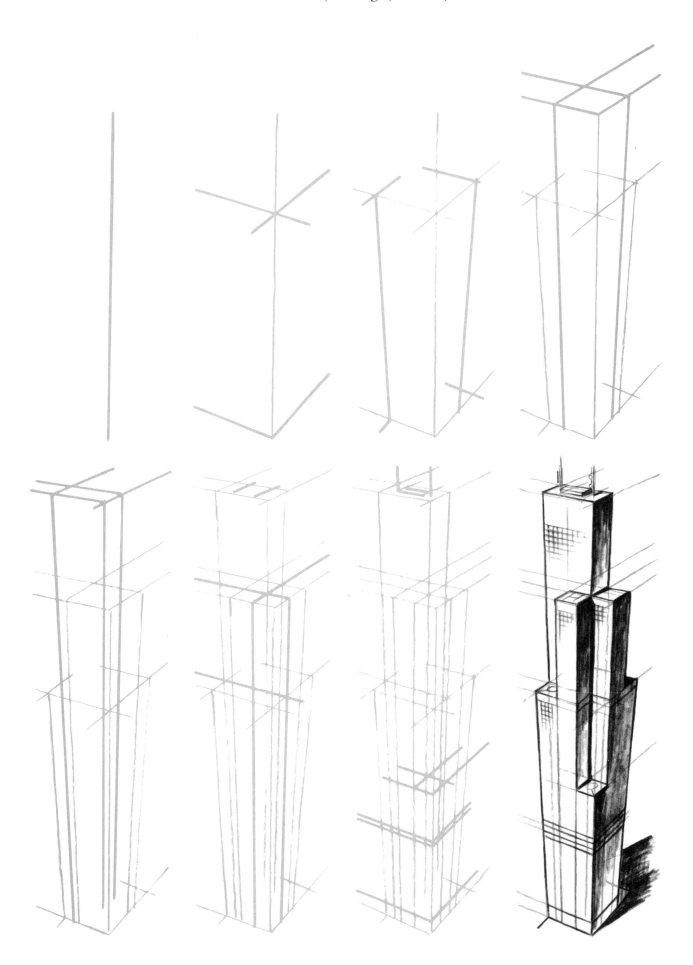

Dome of the Rock (Jerusalem, Israel)

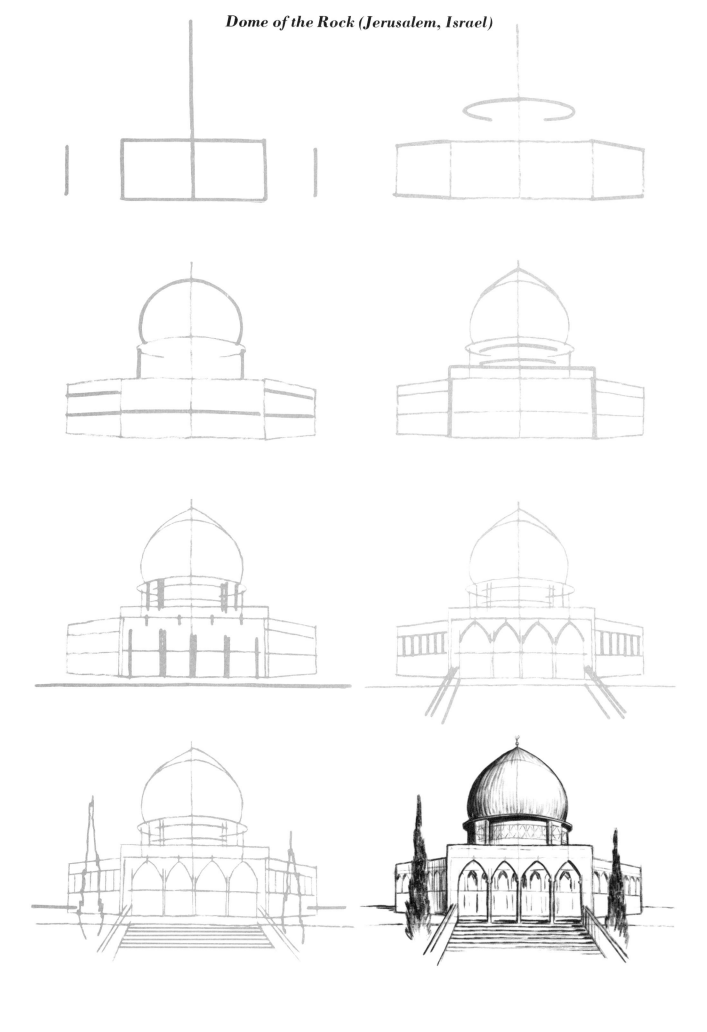

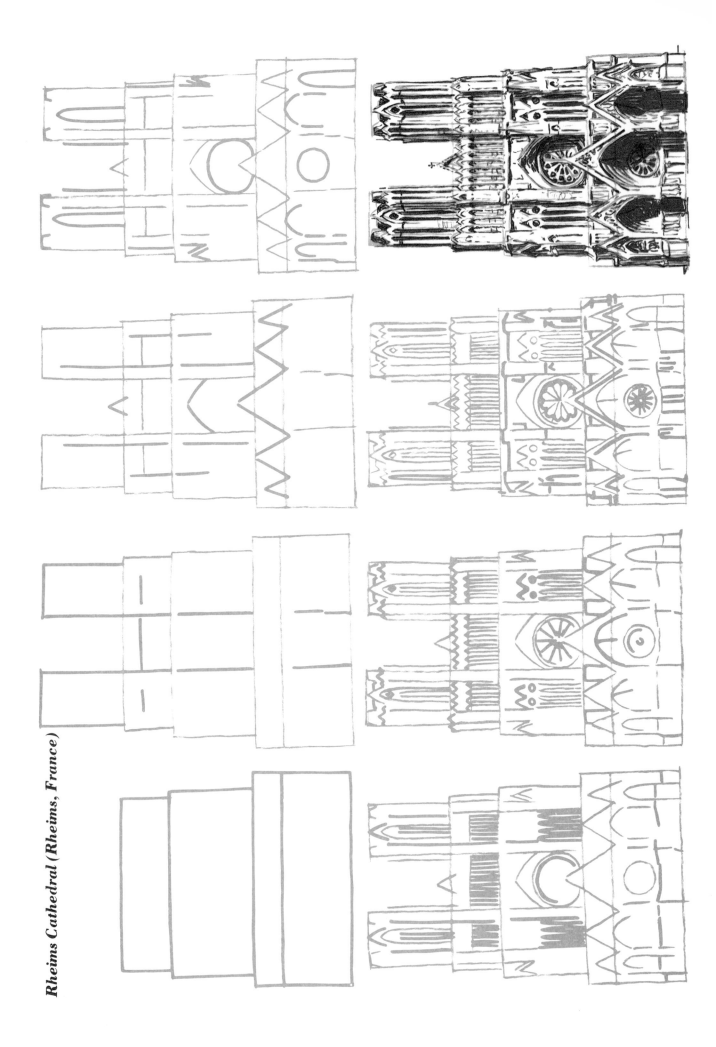

Rheims Cathedral (Rheims, France)

The Church of St. Basil (Moscow, U.S.S.R.)

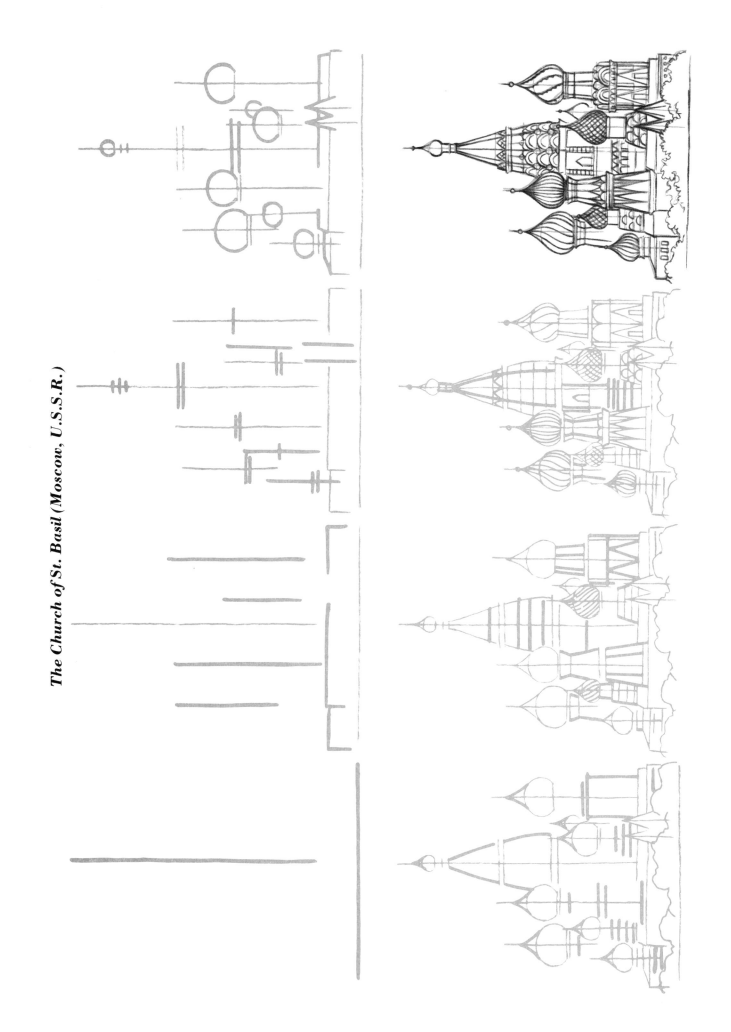

Castle

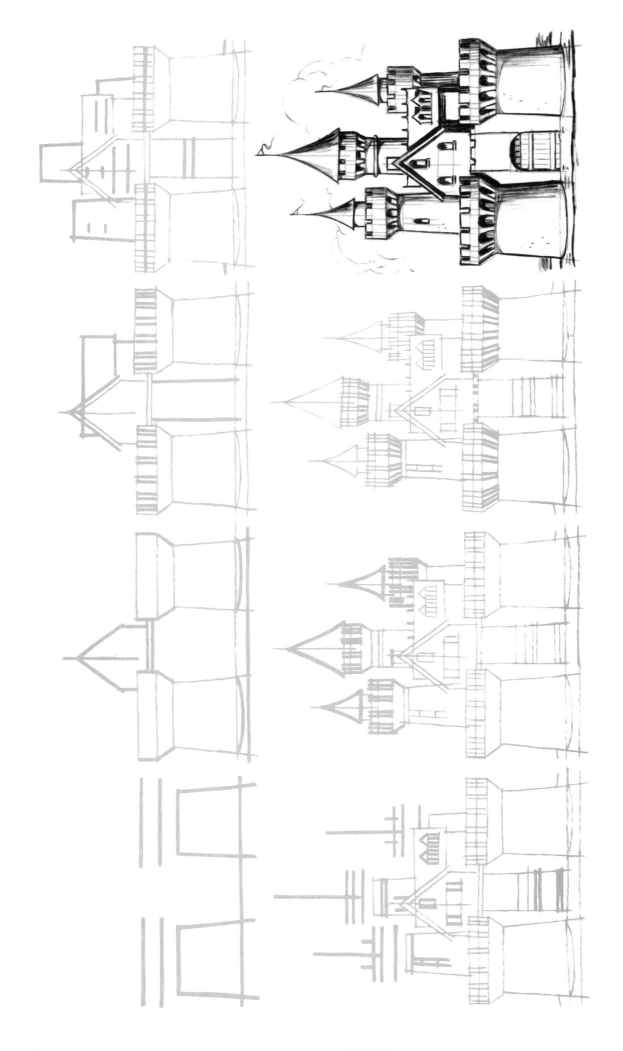

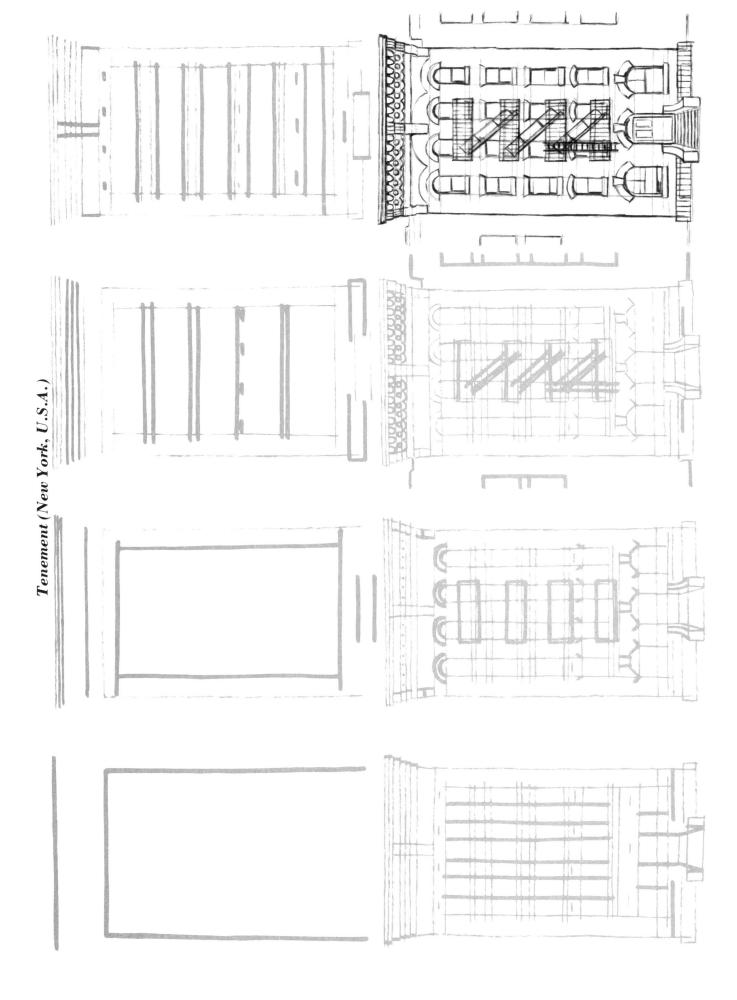

Tenement (New York, U.S.A.)

Chalet (Switzerland)

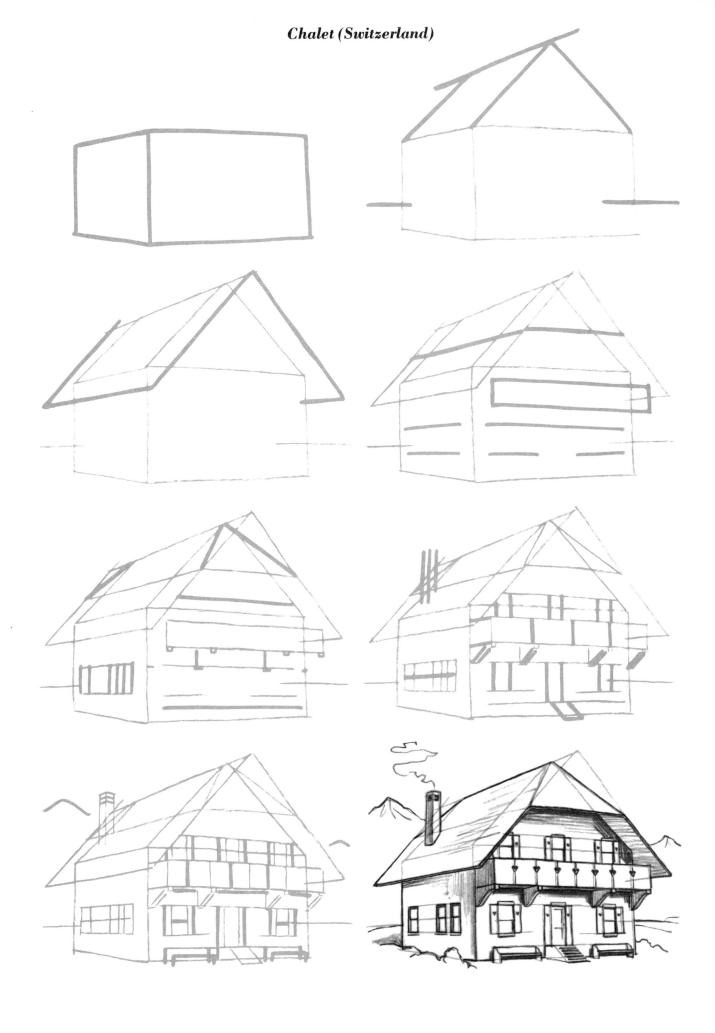

Pagoda (China)

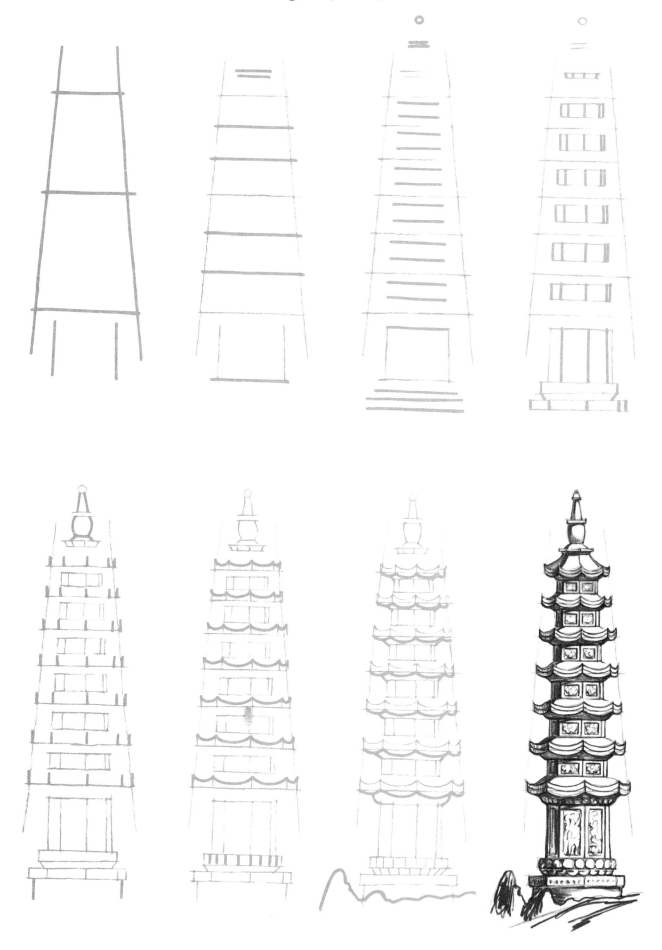

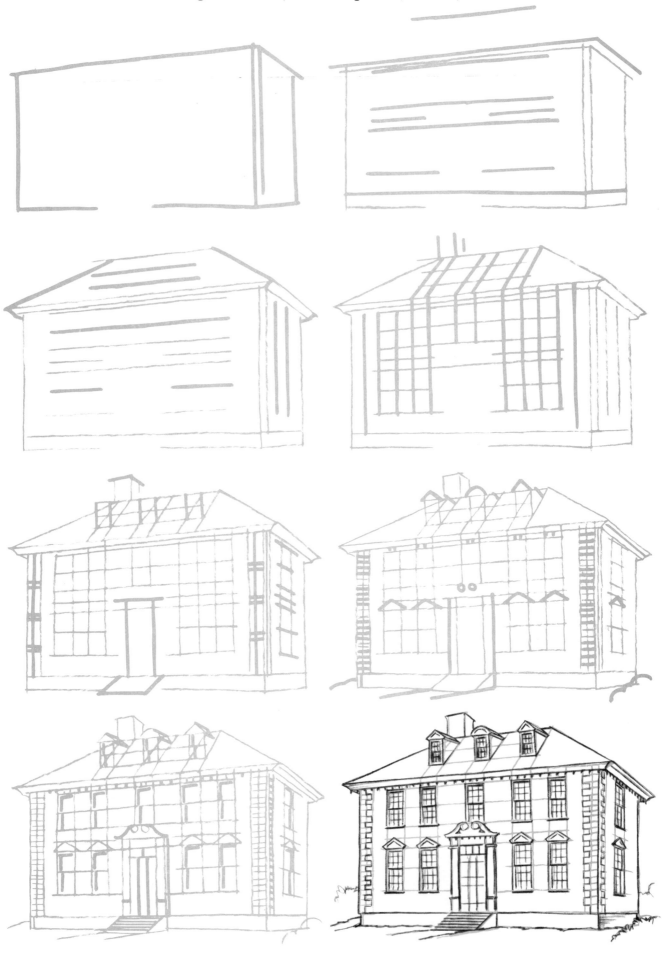

Native House (Sumatra)

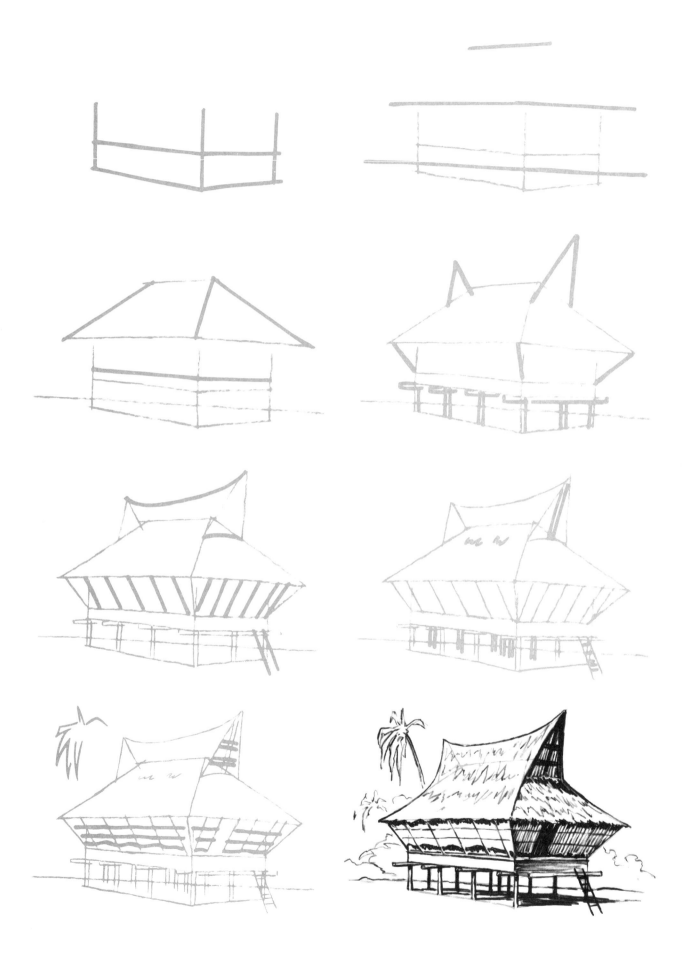

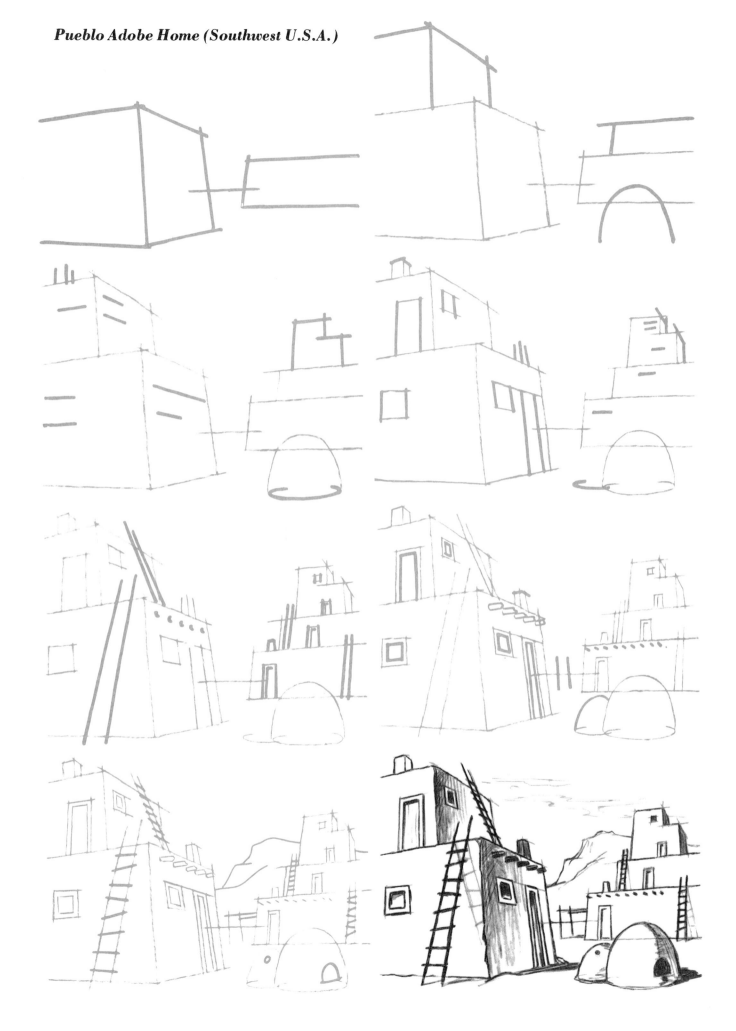

Pueblo Adobe Home (Southwest U.S.A.)

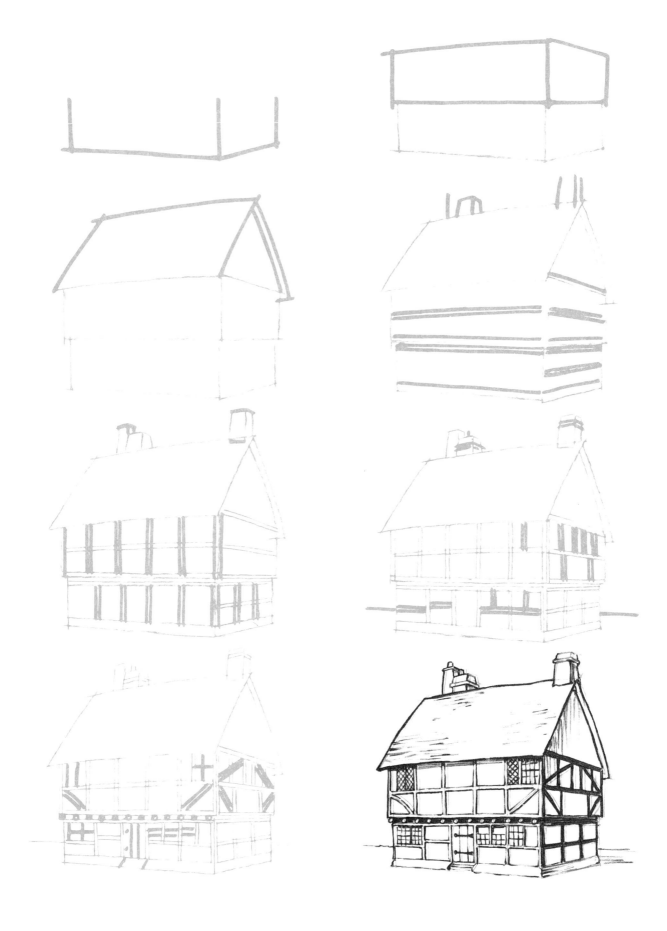

Salt Box House (Massachusetts, U.S.A.)

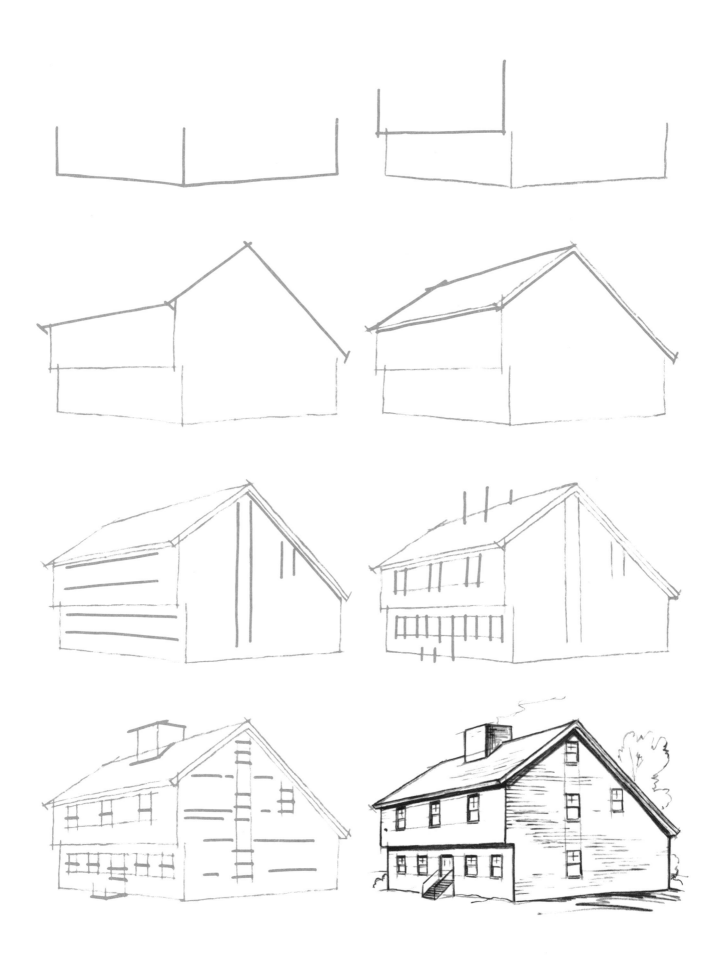

Modified Cape Cod House (U.S.A.)

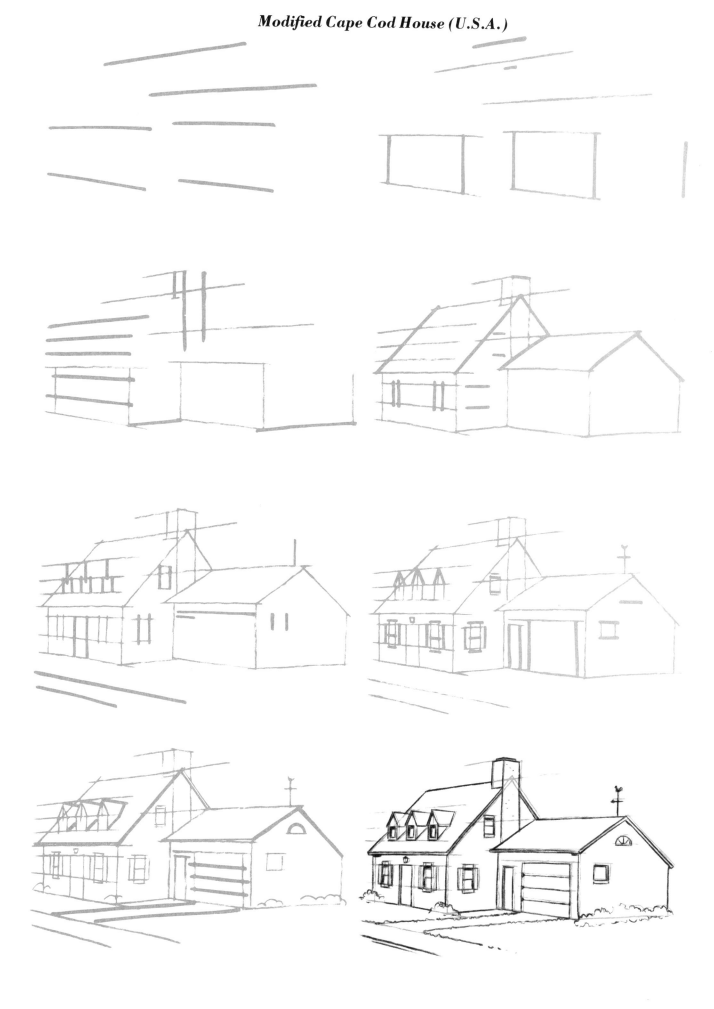

Thatched Cottage (Ireland)

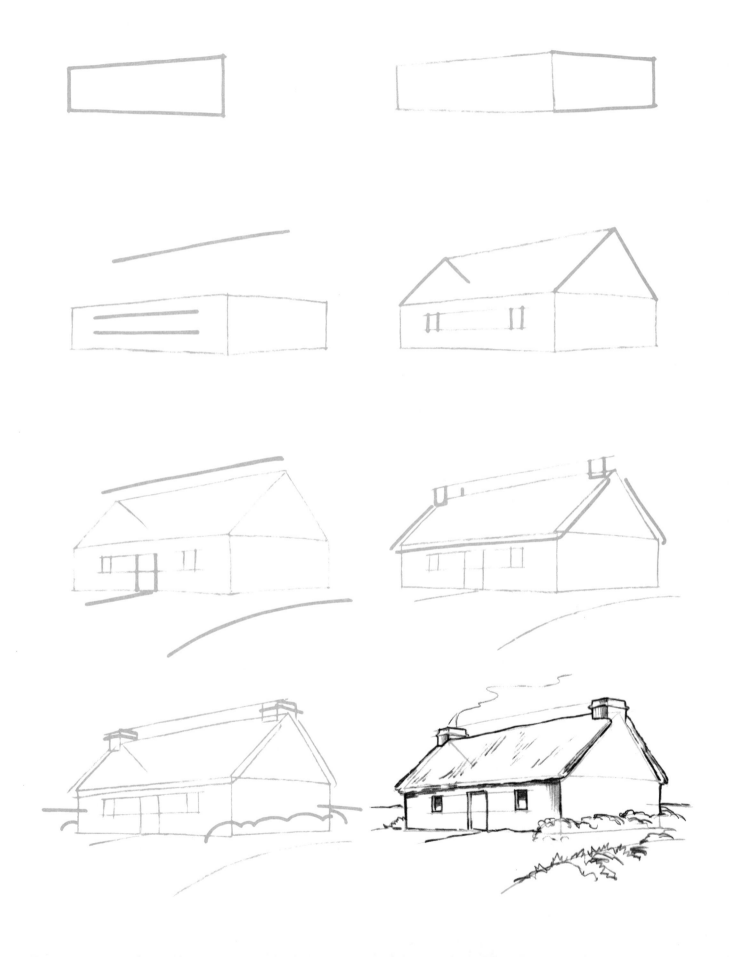

Southern Colonial House (U.S.A.)

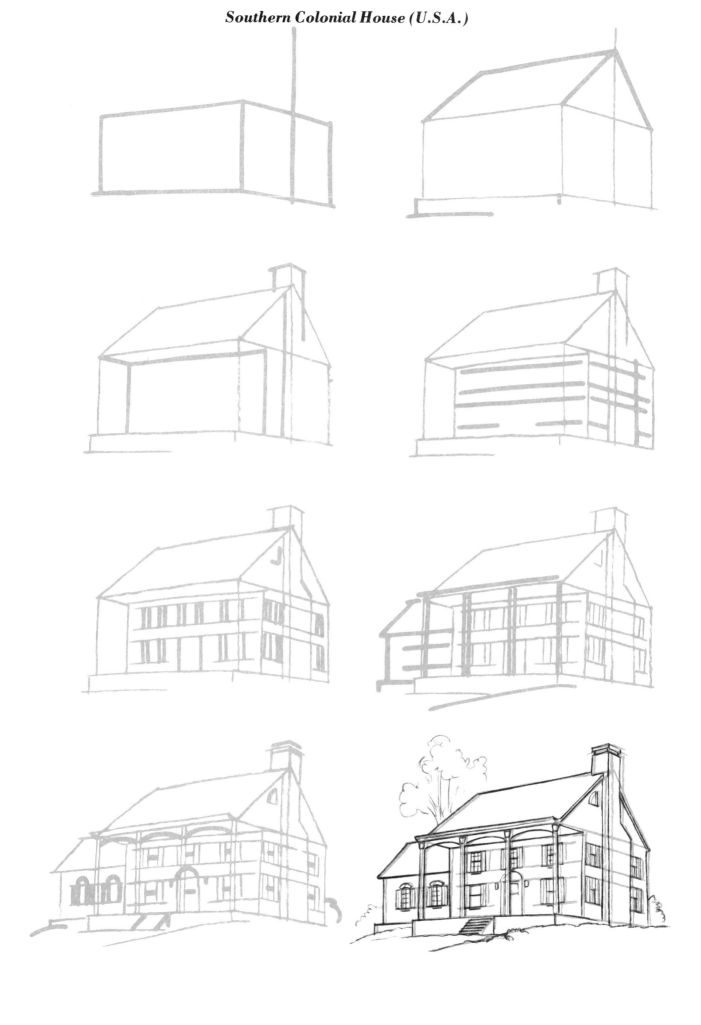

Sudanese Hut (Africa)

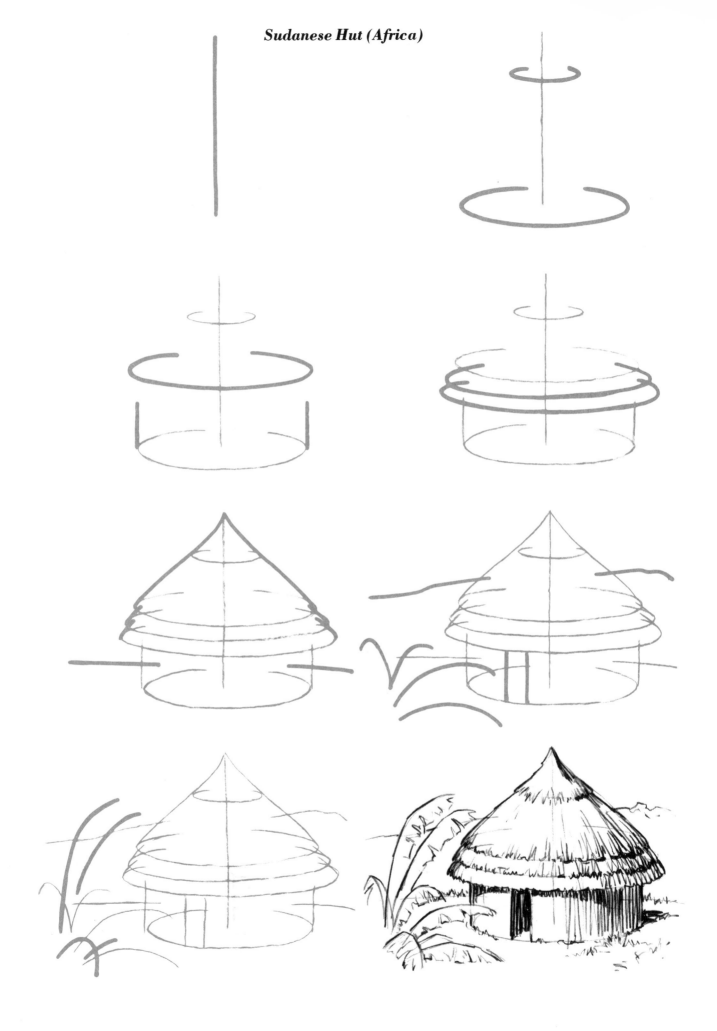

Log Cabin

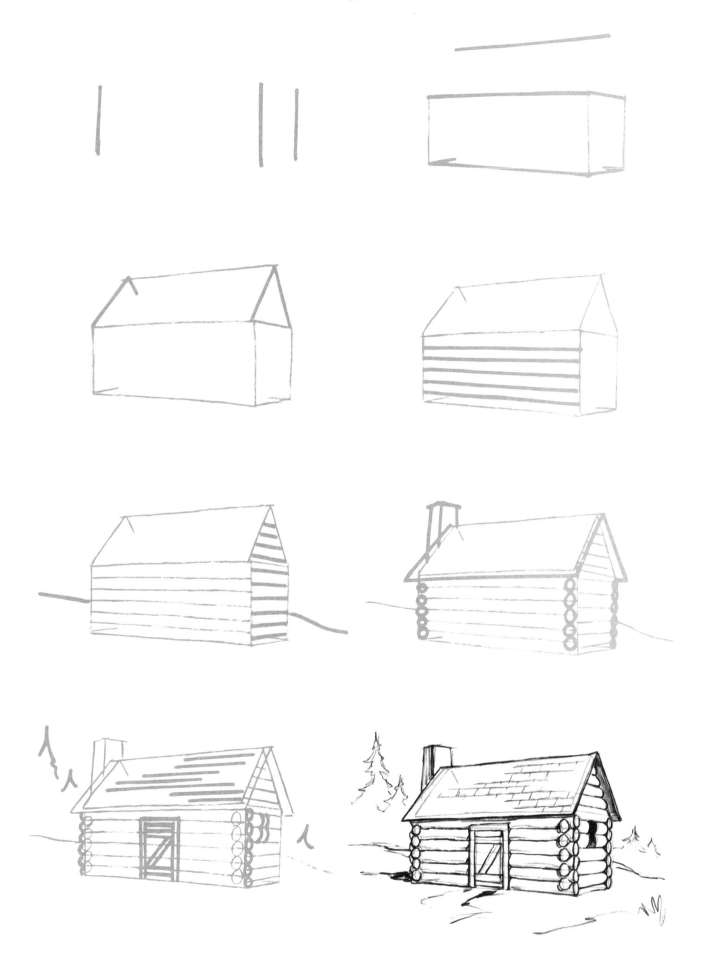

American Indian Tepee

Eskimo Igloo

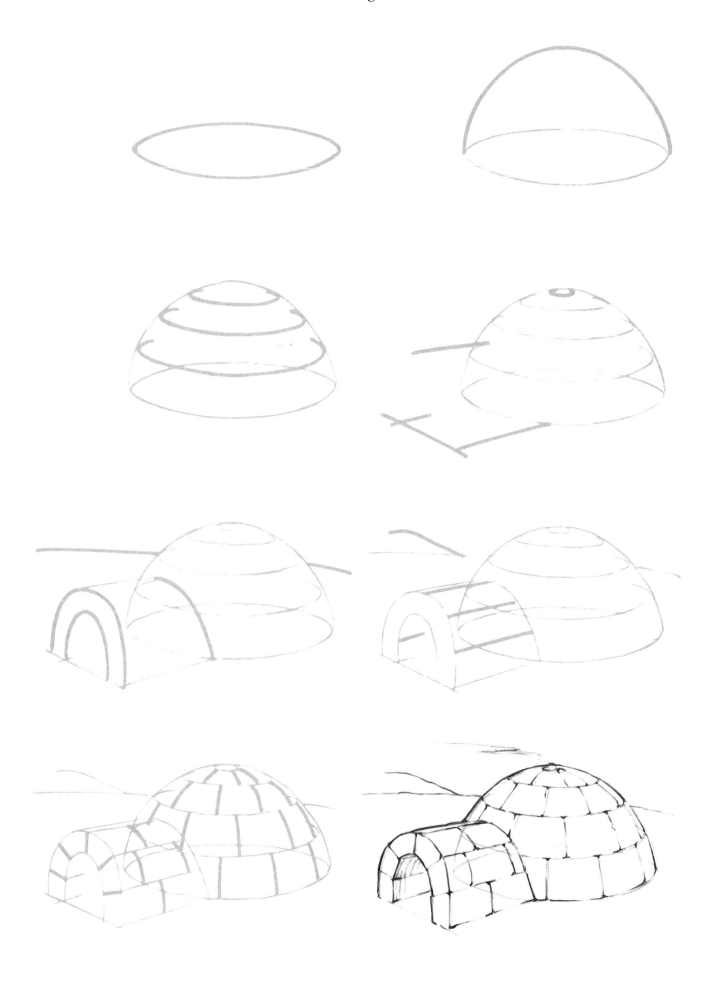

Shack

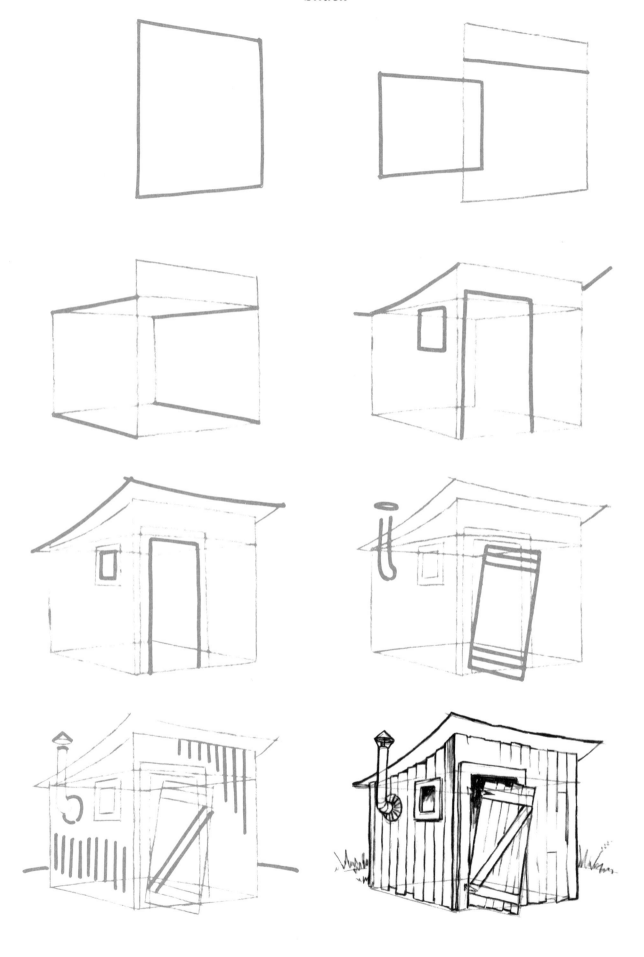

Circus Tent

Windmill

Block House in Stockade (U.S.A.)

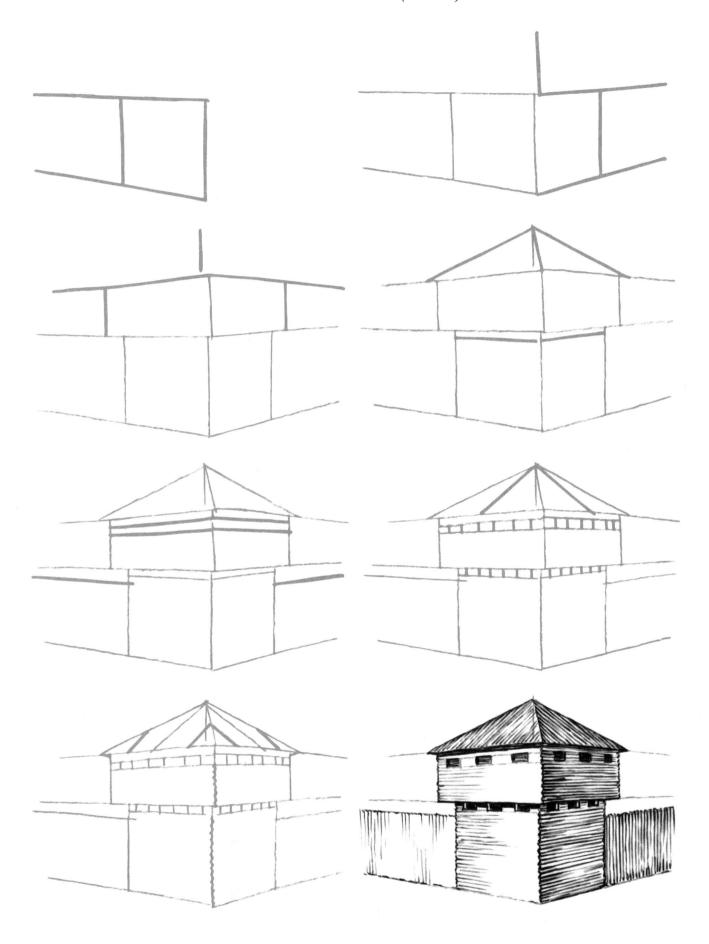

Barn and Silo

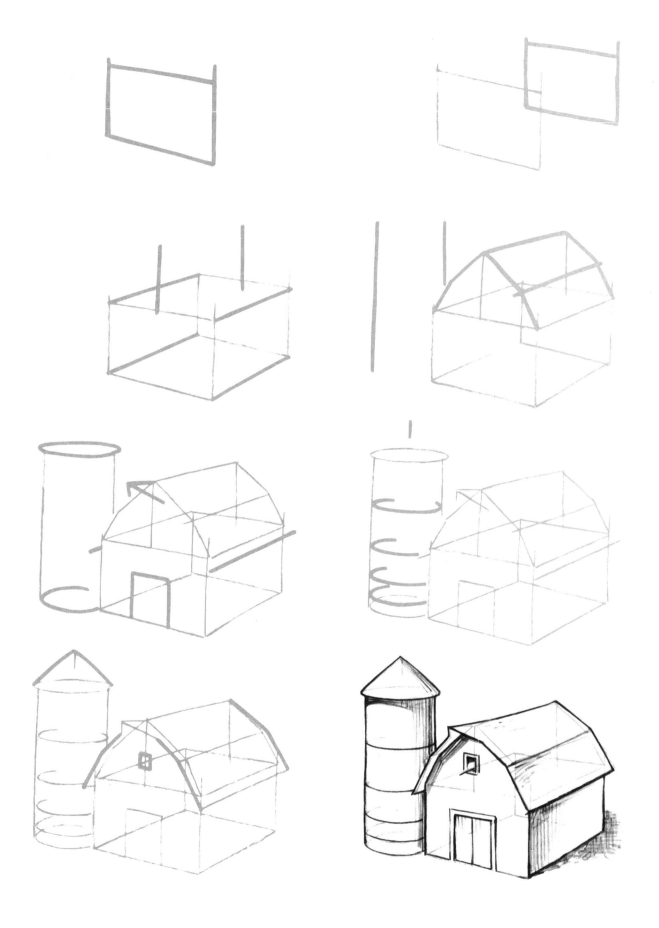

Lighthouse

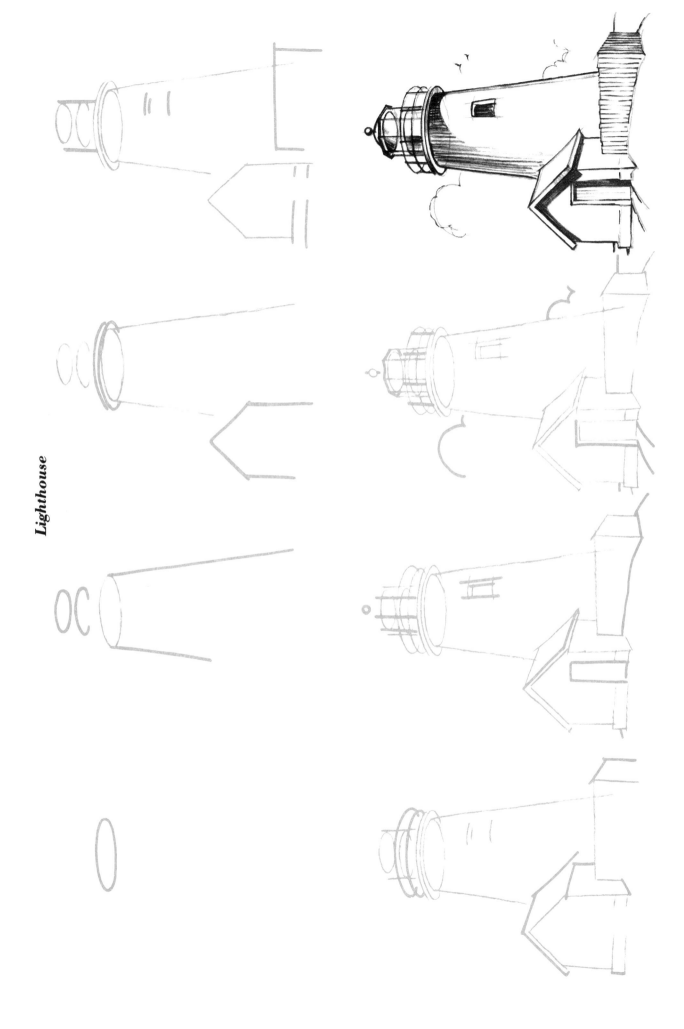

Overshot Watermill

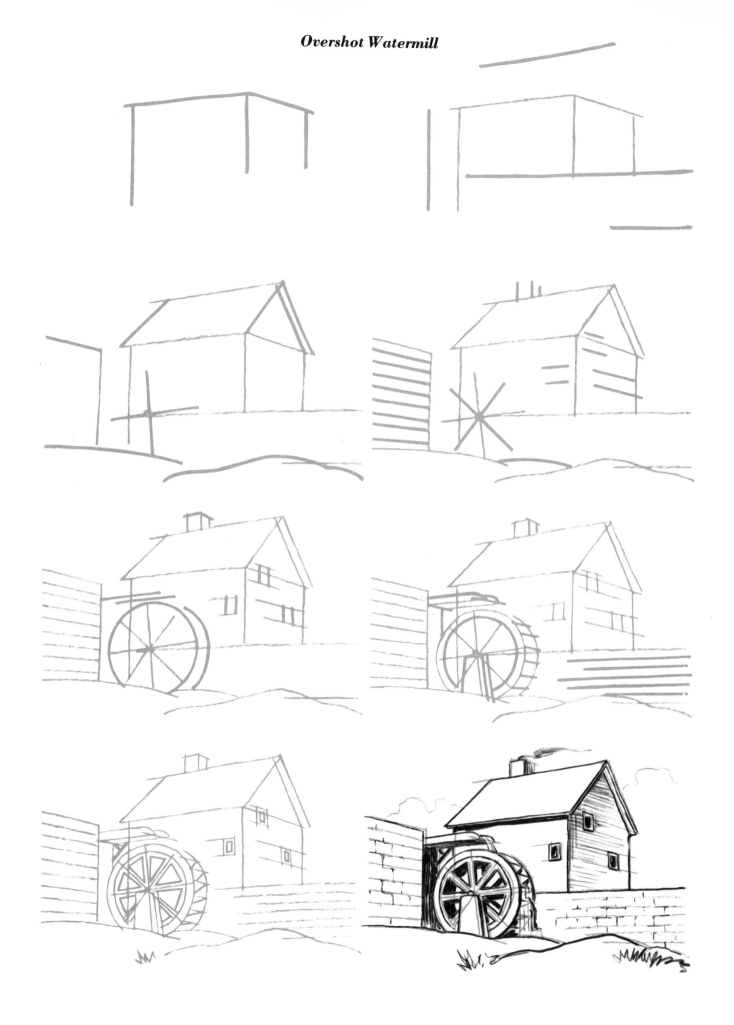

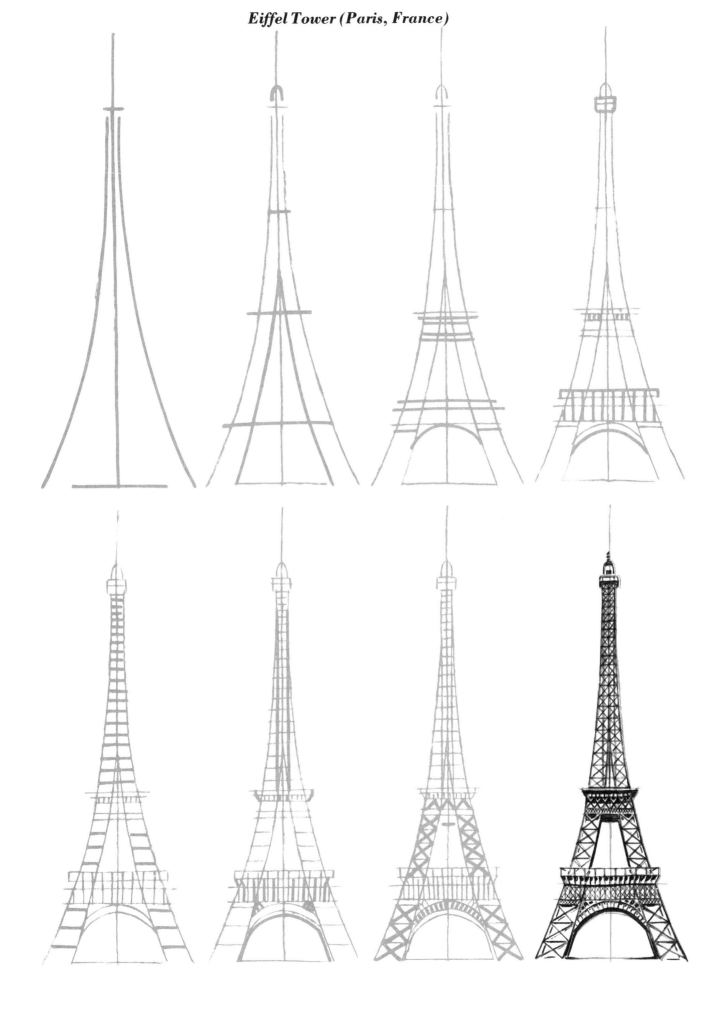

Pyramids (Gizeh, Egypt)

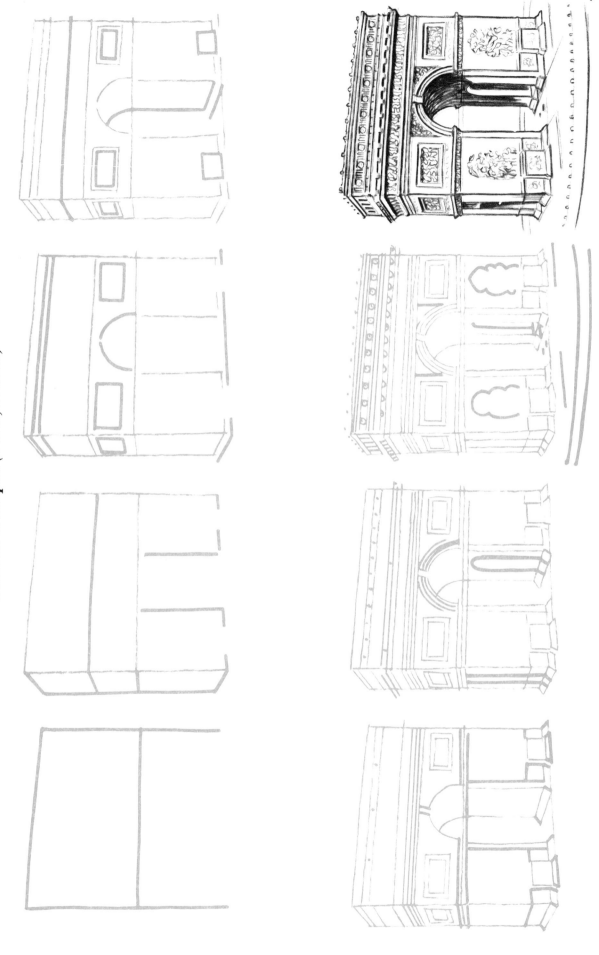

L'Arc de Triomphe (Paris, France)

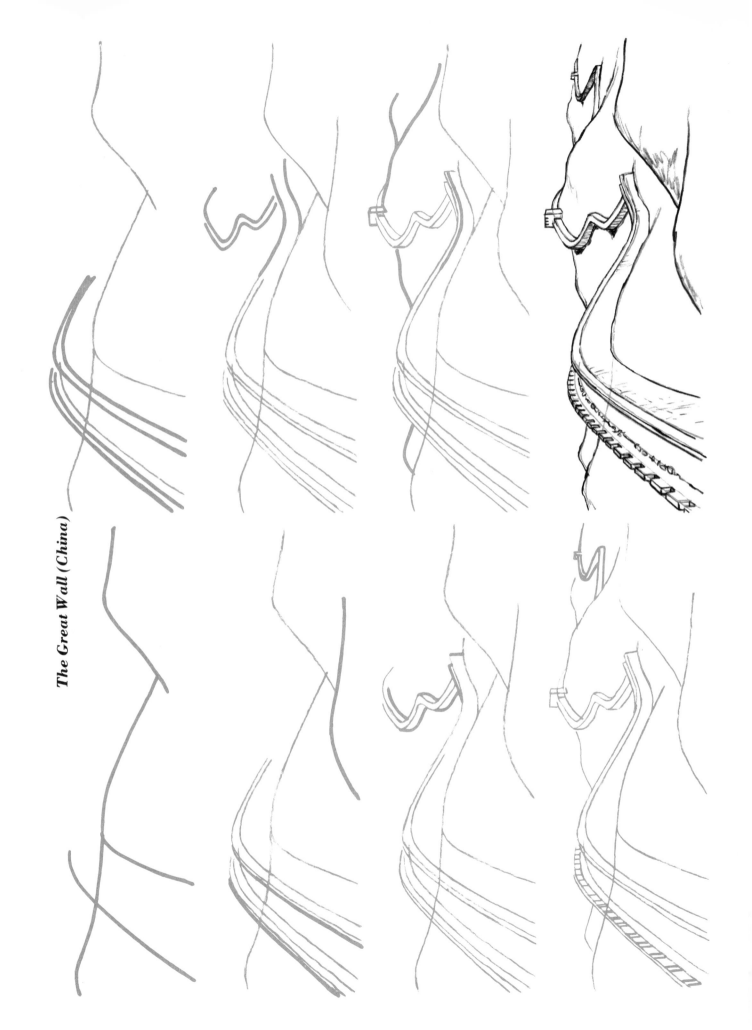

The Great Wall (China)

Mayan Pyramid (Mexico)

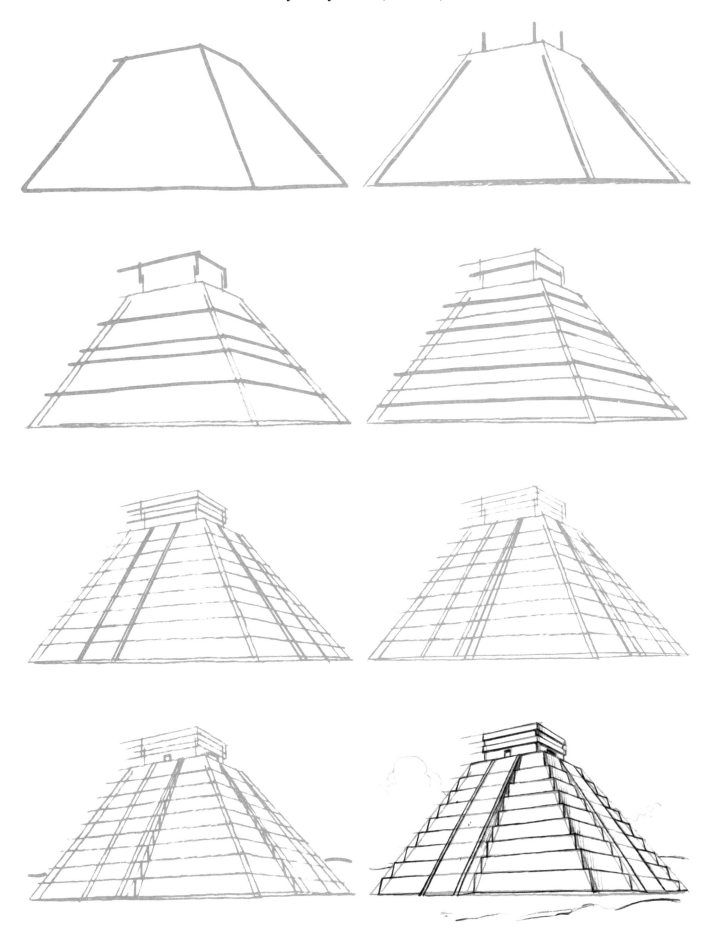

Torii (Japan)

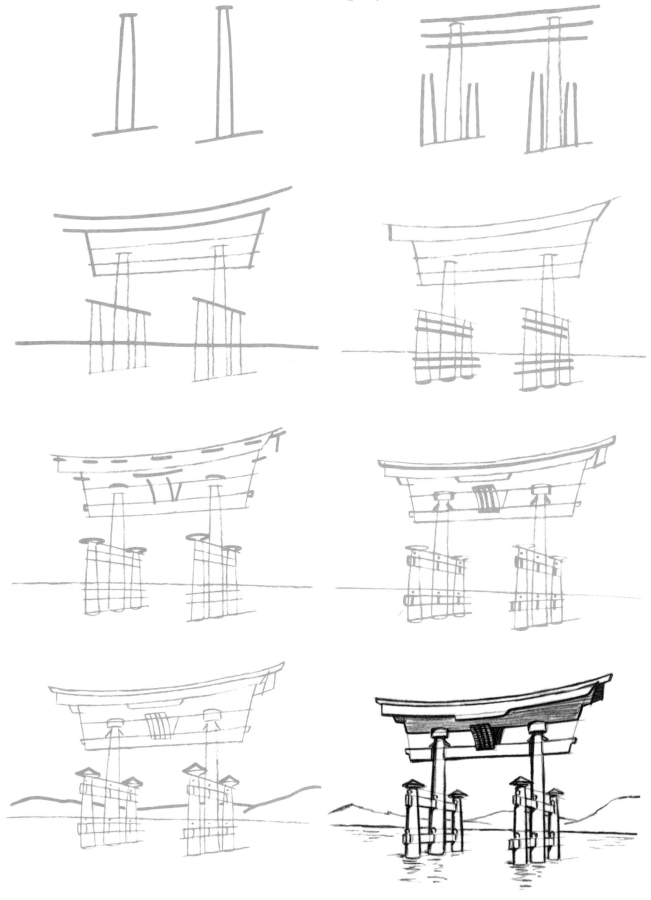

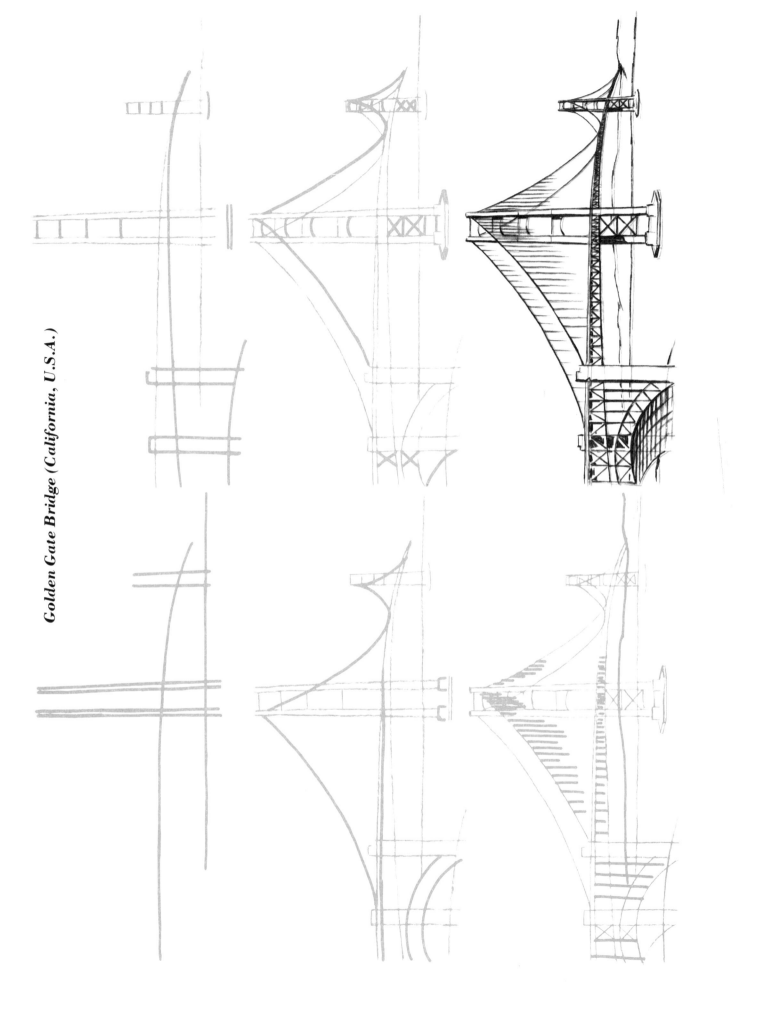

Golden Gate Bridge (California, U.S.A.)

Brooklyn Bridge (New York, U.S.A.)

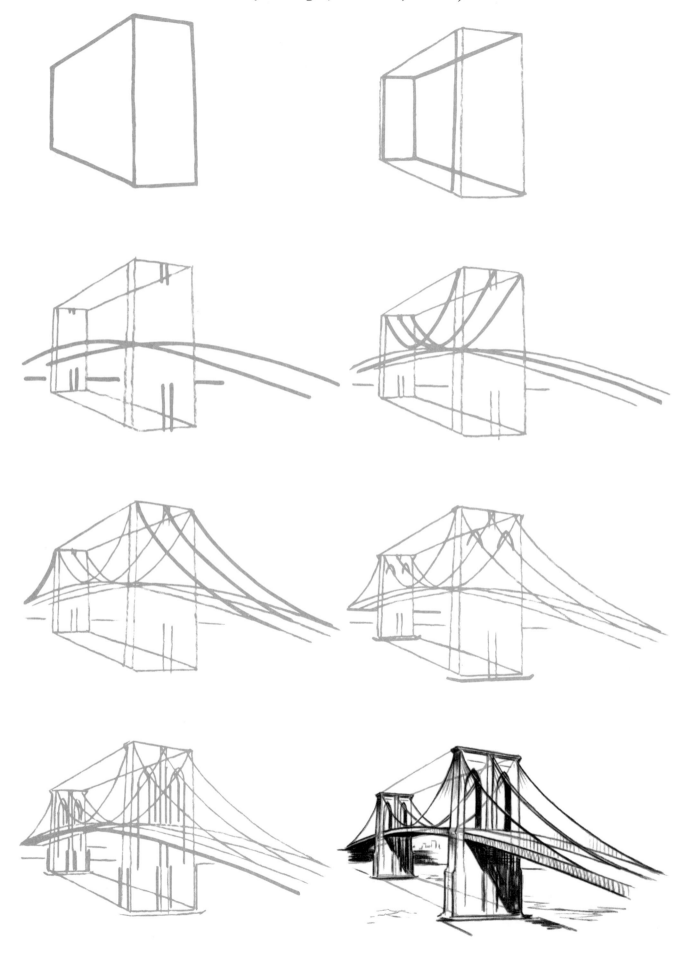

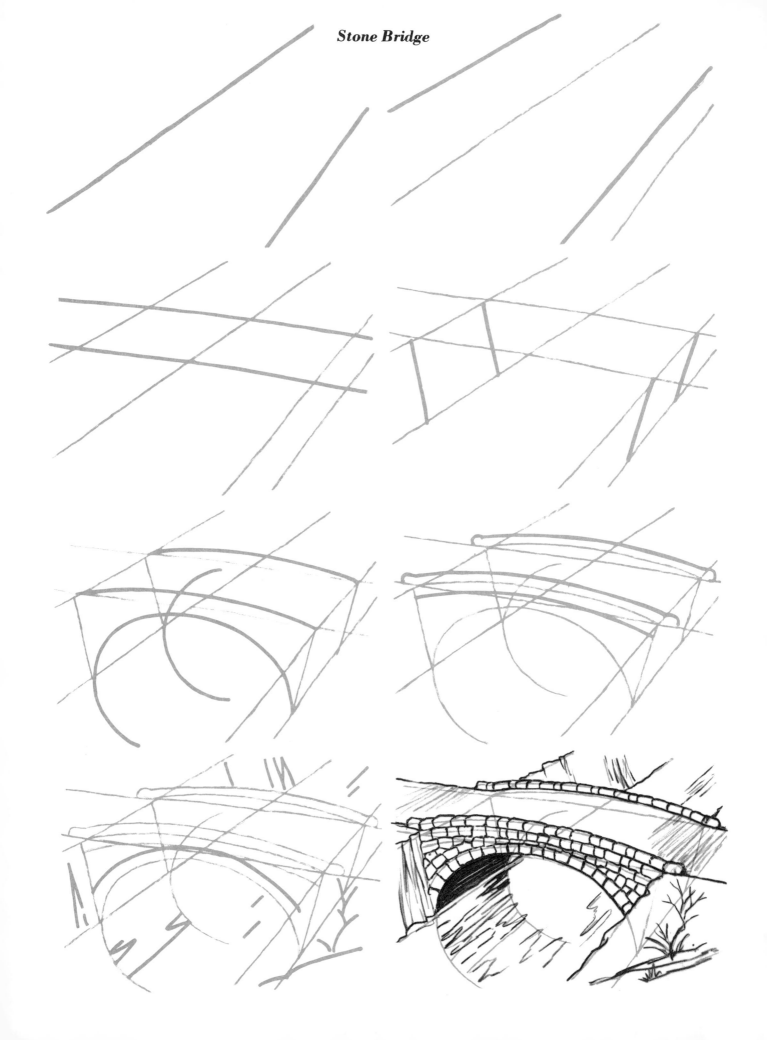

Stone Bridge

Covered Bridge

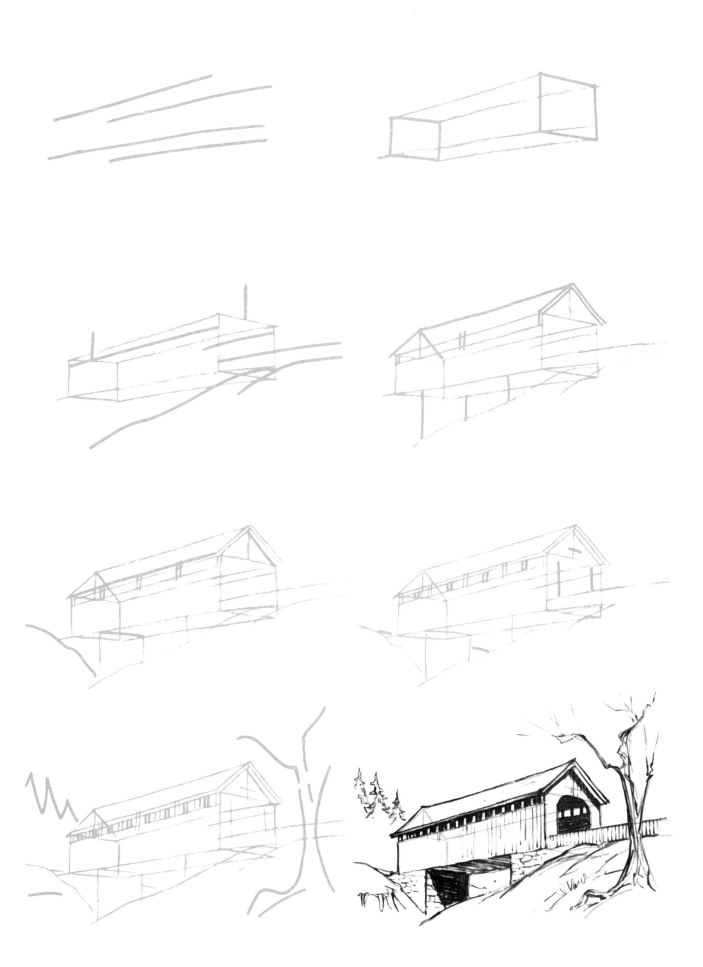

Ponte Vecchio (Florence, Italy)

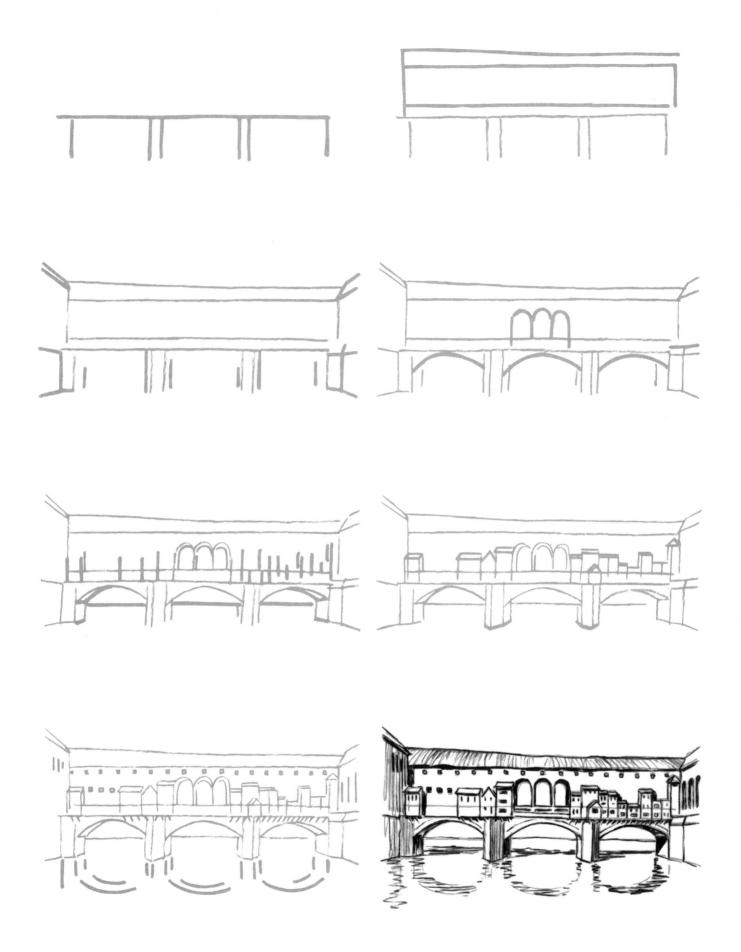

Lee J. Ames began his career at the Walt Disney Studios, working on films that included *Fantasia* and *Pinocchio*. He taught at the School of Visual Arts in Manhattan, and at Dowling College on Long Island, New York. An avid worker, Ames directed his own advertising agency, illustrated for several magazines, and illustrated approximately 150 books that range from picture books to postgraduate texts. He resided in Dix Hills, Long Island, with his wife, Jocelyn, until his death in June 2011.

DRAW 50 BUILDINGS AND OTHER STRUCTURES

Experience All That the Draw 50 Series Has to Offer!

With this proven, step-by-step method, Lee J. Ames has taught millions how to draw everything from amphibians to automobiles. Now it's your turn! Pick up the pencil, get out some paper, and learn how to draw everything under the sun with the Draw 50 series.

Also Available:

- *Draw 50 Aliens*
- *Draw 50 Animals*
- *Draw 50 Animal 'Toons*
- *Draw 50 Athletes*
- *Draw 50 Baby Animals*
- *Draw 50 Beasties*
- *Draw 50 Birds*
- *Draw 50 Boats, Ships, Trucks, and Trains*
- *Draw 50 Cats*
- *Draw 50 Cars, Trucks, and Motorcycles*
- *Draw 50 Creepy Crawlies*
- *Draw 50 Dinosaurs and Other Prehistoric Animals*
- *Draw 50 Dogs*
- *Draw 50 Endangered Animals*
- *Draw 50 Famous Cartoons*
- *Draw 50 Flowers, Trees, and Other Plants*
- *Draw 50 Horses*
- *Draw 50 Magical Creatures*
- *Draw 50 Monsters*
- *Draw 50 People*
- *Draw 50 Princesses*
- *Draw 50 Sharks, Whales, and Other Sea Creatures*
- *Draw 50 Vehicles*
- *Draw the Draw 50 Way*